I'M AN ACTOR, THEY DON'T GET IT

TIFFANY BLACK

Copyright © 2009 Tiffany Black

All rights reserved.

ISBN-13: 978-1502866165
ISBN-10: 1502866161

DEDICATION

This play is dedicated to every actor who had no idea how to become a working actor, but moved to Los Angeles to make it happen.

I'M AN ACTOR, THEY DON'T GET IT

ACKNOWLEDGMENTS

This play was an experiment of energy placement. The idea began over lunch with a friend after I was cast in a rickety play in Hollywood right after acting school. I was frustrated with the director's ability to make money despite the lack of showmanship and effort put into the production. We could barely call it a production. During an intermission, I challenged myself with writing a better show. I knew it couldn't be any worse than what I was already experiencing. I had a concept in mind before I went back on stage but by the time the run of show ended, my relationship with my friend had unraveled. I was crushed and felt abandoned. We pledged to takeover Hollywood together and now I had to tough it alone.

To keep my mind off my loneliness and heartache, I vowed to write every time I started feeling down on myself. I deliberately focused on placing my energy in a positive place. I finished the entire play in two weeks. I didn't own a computer at the time so I wrote at work, on receipts, and on friends' laptops until I flushed out every thought. I'd like to thank my boss at the time and fellow actor, Fred Fate along with my Los Angeles family, Alaisha, Shoniqua, and Niana. You all supported me through the first draft and all three runs of this play.

When I finished the play, my pain wasn't cured so I figured I needed something else to channel my energy towards. I started looking for theatres. I ended up at a small theatre on La Brea that was in worse condition than the one in which I'd first performed. The owner didn't care what we performed as long as he got half of the ticket sales. I signed a contract and immediately held auditions. The casting process was fascinating. I met so many actors who inspired me to command rooms and roles. I was impressed with the talent. I pretty much collected everybody I wanted to be around. Because the show is devised of monologues and vignettes, I didn't have a set number of actors in mind. I just kept I fell in love with. We started with 16 actors and ended up with 12. If you've never done theatre you know, that's a lot of people in one cast!

We set out to produce a great show. I wanted it to be so entertaining that the audience would not have time to look at their programs. We had a diverse, talented group of singers and dancers. Going to rehearsal was exciting even though I had no idea what I was doing. I just remember wanting the production to tell a story that no one would forget. I wanted to give my family a reason to visit L.A. and be proud of me. I wanted this story to speak to every actor in Los Angeles who was finding their way. I wanted my actors to speak words they liked. I realized putting together a show was more than writing a play. I knew nothing about stage design. Luckily, I worked for a theatre program so I was on the hunt for students who were studying exactly what I needed. I'd like to thank Ismael Corona for making the heavy props. I recruited Brande Crockett to be my Stage Manager. She was young, reliable, smart and also had a car, something I didn't have. She was committed to the play and I was lucky to have her. Alaisha, who I affectionately refer to as Mamalaisha, became my Assistant Director. She did everything I needed her to do and more. We rehearsed for six weeks and before we knew it, it was showtime. I was nervous so I walked to the theatre, which was less than two miles from my house. I couldn't risk waiting for the 212 bus and being late. Mamalaisha and Renee collected and sold tickets at the door so I could pace the hallway in peace. I didn't cast myself in the first show because I didn't want my acting or directing to suffer. At the time, I wasn't too sure I was good at either. As a favor to my cast, I decided to focus on directing and producing.

I secretly cried when the first run was over. We managed to get some reviews and even performed at the NAACP Theatre Festival. We all became really close to one another and I didn't want it to end. I graciously thank my first cast: Marc, Tyler, Kyoko, Jasmine, Rebekah, Rachel, Nicole, Jillian, Mandela, Everett, Danette, Parnia, Alvin. Thank you Shoniqua for giving the singers vocal direction and Ashlee Katrice for the choreography. Thank you Kristian Steel for all of your help with the technical details and the LACC Theatre Academy for being an incredible resource. Thank you Jasmine Greene for producing the soundtrack for the play. Thank you Kevin Chaney, JaLisa Sample, Jey Holman, and Makeva Jenkins. Georges Etienne, thank you for donating graphics. Drico, you never wanted to be mentioned but you always supported me and I thank you for giving me everything I needed to make this play a reality. I'd also like to thank Teresa Dowell-Vest. I learned so much from you being my director during my last semester of acting school. You are incredibly talented and it changed the way I viewed the stage.

2009 was a magical year for me. During the time between the first and second run, I was introduced to a woman who would become one of my mentors, Joy Bryant. I want to thank you for telling me repeatedly that I am DOPE. And I thank my sorority sister, Asia, for believing in my craziness

and introducing me to Joy. Thank you for taking a chance on me, Emil. You'll never know what my Essence column meant to me. My column was appropriately named: I'm An Actor, They Don't Get It. Mamalaisha was there to proofread my articles along with so many others. Katie, Ashley Blaine, Reggie Reagor, my sisters, Kiana and Kesha, Jemier, Guerline and everybody else I have tricked into proofreading my Essence blogs - thank you!!!

I maintained the same cast through the first and second runs, but decided to deliver an all-black cast for the third run. We secured The Stella Adler theatre on Hollywood Blvd and the experience was one of the most challenging things I have ever endured. I joined this show as a performer and maintained as the Director and Producer. Needless to say, this show was my entire life. The third cast was strong and tolerated things no cast should ever have to. For your patience and commitment, I thank Jermaine, Owen, Tristan, Alex, Whitney, Dayna, and Raquel. Stan Harrington, you were amazing to work with. Thank you Danielle Hobbs, our choreographer. Pegah, Tami, and Ursula, thank you for all of your help! I also thank the Beverly Hills Chapter of the NAACP for all of your support over the years.

Ultimately, I think this show became a huge business card for everybody. I cast the actors but we all did a bit of everything to make the show a success. It allowed me to be able to show all of the wonderful things I wanted to do in my career. I had the chance to grow and work with some of the most talented people I have ever met and before it was all over, I got that friend back and so much more. De'Garryan, you were never able to see a run of the show, but thank you being at my first play in Hollywood and sticking around even though it wasn't great. Thank you for formally introducing me to acting that day in Bills Bookstore, you give me confidence. To my family, thank you for always supporting me. I know y'all still don't get it but you love me anyway and that's all that matters. I know I have a lot of people loving me from St. Pete, Florida! Thank you Justin Hires for being my friend and always looking out for me in Cali. I humbly thank everyone who supported this show in any form or fashion. Because of this play, I got the chance to be pulled in a million creative directions. I found love and support in places I thought I'd never find them. As I look back on the woman I was in 2009, I make myself proud. I was daringly ambitious and possessed the audacity of hope. As actors, we need both ambition and hope so badly. I hope this play gives a spark of fire to every actor who reads or performs it. I hope this play lends some empathy to those who are not performers. In the end, I hope you get it.

TIFFANY BLACK

ACT ONE

1	The Declaration	Pg 1
2	Home. Sick.	Pg 3
3	College Grad	Pg 5
4	Coaches with No Creds	Pg 7
5	Passport Performer	Pg 8
6	Student Films… Never Again	Pg 10
7	The Thrill of Being Signed/ Where's my Agent?	Pg 11
8	Fuck it, I'll Just Be A Photographer	Pg 12
9	The Living Headshot	Pg 13
10	The Life Saver	Pg 15
11	Full House Empty	Pg 16
12	Better Math	Pg18
13	The Messenger	Pg19

ACT TWO

1	Super Excuses	Pg 22
2	I'm The Shit	Pg 26
3	Sizing the Competition	Pg 27
4	Audition Crashing	Pg 29
5	Analytical Actor: Fuck it, I'll Just Be a Casting Director	Pg 30
6	So Much Life… Outside the Room	Pg 31
7	Too Much Like… Me	Pg 34
8	Waiting For The Callback	Pg 38
9	Love First	Pg 39
10	I'm Scared	Pg 41
11	Family Support	Pg 42
12	Packing Light	Pg 43
13	Giving in to Giving Up	Pg 45
14	The Declaration 2	Pg 48

I'M AN ACTOR, THEY DON'T GET IT

THE DECLARATION

(Actors enter stage from various entrances. Actors warm up, stretch, do a space walk as their characters, various & multiple crosses, exchange business cards, headshots are visible. Actors are dressed differently and are all very individual. They exist individually as lead actor emerges. Music fades. Lead actor in regular text. Entire cast in bold text from off- stage.)

I'm an actor. This is not just a hobby, an elective, or a job. At times it can't even be considered a job, because I'm not even making any money. I am an actor because **it's the only thing I love to do.** I can't help it. I do it without even trying. I study people, the way they walk, talk, live life. It fascinates me. **This is my passion,** my childhood dream, my only dream. I gave up everything to come here and do this. I know there are thousands of people who move to L.A. every day to do what I want to, but I don't care. I know there are thousands who pack their bags and give up every day, and I don't care. I'm different. I am going to make it. I have to. **If I don't act, I die.** If I don't make it I have nothing. **I refuse to go home empty-handed.** I've already promised my mom a new house. She's picking out carpet! So I have to make it. I've been waiting on this my entire life. I can see it. **I see it.** I smell it. I'm not like all these other fools who get off the plane and hope to get discovered in a coffee shop. I don't care if I never become famous. I do want the money! **But most importantly, I just want to act.** I want to tell beautifully amazing, life-changing stories. Miracles happen to human beings every day. We don't share in those stories enough. When we watch movies, TV shows, plays, films, we look into people's lives. **We learn.** Our minds expand, we make fewer mistakes. We have compassion for others. We actors are able to touch other people and enhance lives. I know it's not going to be easy, and I look forward to the hard work. This is what I love to do. **I won't stop until I make it.** I'll

continue to go on countless auditions. I'll work for free. I'll act for food. Those who are not in this industry may never understand my dedication to my hustle. **I'm an actor, they don't get it.**

I'M AN ACTOR, THEY DON'T GET IT

HOME. SICK.
1 FEMALE

(An actress is seen alone standing near her luggage.) My hometown wasn't enough anymore. I had taken all the dance classes I could take, booked all the local commercials, I was prom queen my junior and senior year, and crowned Miss Tween Georgia. Talk about being a big fish in a small pond. I was just over it. I wanted more. If I ever wanted my career as an entertainer to go any further, I needed to live in a big city. I love my home. There is nothing like being around people who love you. I have a seamstress who has been making my dresses for pageants since I was five years old. I've had so many dance classes I became an instructor at the studio in high school. I have been doing all these things, the pageants, the dancing, the commercials…because people have all told me that these are all the prerequisites to becoming a diverse actress. Everything you experience in life makes you a better artist. I've been told that a thousand times. There is so much competition. You have to be groomed, developed, and advanced in many things. Never give them the chance to tell you no. *(Exhale frustration.)* I'm just about perfect. And now that I am in the big city, where I should have been discovered upon arrival, I don't know what to do. Usually people move here and join an acting class or a commercial class or something. I have acting experience and I've been booking commercials since I was seven. So now what am I supposed to do? I'm in L.A. and there is no one here to tell me which way to go. I'm too scared to trust anybody so I don't know anyone besides the older people who work at my job. I put so much focus towards getting to where I am, that I don't know what to do now that I am here. I audition, but they're all small indie projects. Who knows if that stuff will ever lead to anything. I don't know which way to go now. It's almost like I'm so qualified, I don't qualify for anything. I have so much to give. I have so much to show the world, but now that I'm here, it's like I'm lost in the shuffle. There are just so many girls holding titles, who

dance, and sing, who act, with this color hair *(Grabbing a piece of her hair)* ALL AT THE SAME TIME. I'm having the hardest time deciding if it's better to be the best in a small town or a nobody in the big city. It feels like I traveled thousands of miles to…aspire to do something I was already doing, and doing very well I might add. It's not giving up if what you thought would make you happy doesn't. I'm not going to try to be happy when I can just be happy. At home, I don't have to prove to anybody that I just want to perform. I don't have to convince anyone that I am a talented, well-trained actress. I just am. And that's enough for me. *(She picks up her luggage and exits the stage. Music plays softly and eventually morphs into a faster paced song. A male actor enters the stage to help her carry her luggage off. Another actor makes a cross sweeping the stage. A small table for dining is brought on stage. An actor seats two patrons to their table. The actor exits. A male actor enters and takes center stage.)*

I'M AN ACTOR, THEY DON'T GET IT

COLLEGE GRAD
1 MALE

(Male walks in wearing black slacks and a white shirt.) I'm an actor, they don't get it. My family will never get it. So I went to college, you know. I graduated in five and a half years. I did everything right. I earned my degree in Criminal Justice with a minor in business. I harmoniously positioned myself to either be moving on to grad school to become a lawyer with my own practice or if all else failed, I could become a probation officer. My annual net worth began at $40,000 a year and for where I'm from that's a lot of money. That's why my friends and family thought I was just plain dumb to give up on my promising future of being a criminal justice official for acting, something they think I'll never make it in.

It all made sense to me, so I packed it up and headed straight for LAX. When I got off the plane, an old lady asked me if I was an actor. I proudly answered, "Yes." Then she asked, "What restaurant." Mothball! What authority do you have to tell me I'm going to be waiting tables?! You must not know who I am! Why, I have a degree, internships, and no student loans! So I take a couple of days to get settled and start my job hunt. Now, maybe I'm crazy, but all of the jobs that are willing to pay you for having a degree want you to work from 9 to 5. Give me a break. Don't they know that I have to audition during those hours? All the nightshift positions want to pay you, I don't know, if you're lucky, $10 an hour. Why, I can't even take Nino to the vet on a salary like that. This is Los Angeles! I've never even heard of rent being under $800 a month. I'd have to work sixty hours a week at that pay rate. I'll never be able to audition. If anybody ever figured out the answer to this puzzle, he kept it to himself. How does one live in L.A., pay the rent, and still audition? How come casting directors don't just schedule all the auditions at night so that actors can make the auditions! There's less traffic at night, it's not hot outside and then, I

wouldn't have to wait tables to pay the rent. *(Puts apron around his waist, taking a dishrag out of his apron.)* I chose Katsuya.

COACHES WITH NO CREDS
1 MALE / 1 FEMALE

(Male and female walk in and both sit at the table the waiter just finished cleaning.) Katsuya is this amazing sushi spot on Hollywood and Vine. I walk by it a lot on my way to the gym, but on this particular night, I was venturing out. So I'm having an appetizer with an actor friend of mine *(small gesture to reference the woman sitting across the table reading a menu)* who was suggesting that I join her acting class. I'm always open to a new experience so later on that week I audit the class. *(The woman exits the stage; the tables and chairs are removed leaving the actor standing on an empty stage.)* The class might as well have been a one man show because rather than help the actors find their way to the truth in their characters, the instructor would rather get on stage and show you HOW to do it. Then I took a risk and asked the instructor what projects I've seen him in. He mentioned a couple of commercials and one indie film. How in the hell can you even **ATTEMPT** to teach me how to act if you haven't even figured it out yourself? The problem with acting classes is simply that actors who have time to teach them shouldn't be teaching them at all. If you're an actor with an acting class, I hope to God you have a sitcom or something, otherwise I don't trust you. I'd love to take an acting class taught by Denzel Washington, Will Smith or Meryl Streep but the truth of the matter is that they are such amazing actors they are too busy booking jobs! They just don't have time to teach the craft to someone else.

(The cast begins to build a film set background for a student film.) I decided to take Russell Crowe's approach and let experience be my teacher. Who needs a classroom. I'll learn everything I need to know on set.

TIFFANY BLACK

PASSPORT PERFORMER
1 FEMALE

(Reggae music begins to play softly. A young black girl in a wrap dress with snap peas in a bowl walks out. She casually sits down and begins to tell her story.)

When you tink about the Carribean, you tink about te islands, te crystal blue water, te warm, white sand, te beaches and everyting. You no tinks about what life is like every day on tat island. Tose who are not vrom te islands come to our home to escape. Tis is te same way we feel bout te States. When we tink about te states, we tink bout opportunity for good life. When I was back on te island wit me brothers and sisters, we spent a lot of time dreamin. We dream bout life in the States. Anybody we knew who ever made it to the States, live a good life. My mutter and fater went back and forth on boats to buy things from Florida to sell on the islands to make money to feed us. We lived in hut. A very small hut tat would get almost destroyed every time it rained. It rained every day in the summer. So to keep us dry my mother would take us to the hotel she worked at part-time. We'd hide in a closet-sized area with one small television where we'd watch the same movie every day because we couldn't afford a new one. We never cared much, it was our favorite movie anyway, Sarafina! I loved Sarafina. She was so smart. When my mutter was pregnant with me, she and my fater were going on trips to Miami to buy tings to sell. There was a real bad rain storm tat summer and she had me right there in the boat on American soil. It's only because of tat storm that I was able to be considered an American citizen. Of course, me parents take me back to island in tree days but she always told me I'd never need a Green Card. I'd never need a Visa. I could go and come to te states anytime. Knowing tat made me feel like I had a chance. It made me feel that I could be like Sarafina. All the good schools were in the States. All the money was in the States. Good life was in the States. Never knew why Americans want come here when everything they need is in the States. One day while we were at work with my mutter in the hotel we laugh too hard while watching Sarafina. One of the workers hear us and run tell the manager. They fire my mother. She started to have to go to Florida more often to make more money for us. So I started to go with

her. One day while I was in Miami with my mutter to get cigarettes and alcohol for selling, a man comes to me and asks me if I am going to audition later for the cruise. I had only seen those big boats come and go from the island, I had never been on one. My mutter tells me to go. I tell her I can't. I don't want to leave her alone in the States by herself. She reminds me that she comes alone all the time and she don't need me protecting her. When the man heard us talk, he ask me now, "You not from here? Tis is American ship. You must have a Passport." Me tell him I don't have one. He tells me I just need a birth certificate and a social security number. My mutter tell him she have that. I auditioned for the cruise and even got my passport. I sang, and danced, and performed on that cruise for 4 years before I left to live in the States. I never went longer than five days without seeing my family. And we never had to worry about running from the rain. I made enough money for my family to live in a house. Since I left the cruise, I done four plays and a feature film with Sony pictures. People ask me how I make it so young in this industry and foreign country. I say because I never tink twice about whether or not I take a job. My family needs me to be ok and I need them to be ok. I never quit trying new things and I try anything. I love what I do and I can take care of us. Somebody gave me a chance. So I never take that for granted. I know people still on the island who never got the chance to leave. So I make most of my chance, our chance.

STUDENT FILMS... NEVER AGAIN!
1 FEMALE

(The cast takes their places on set of a student film shoot.) I was uber excited to do this student film! It's about a girl who gets killed by a teenage wolf on Elm Street during Memorial Day weekend while walking home from cheerleading practice eating a bag of cool ranch Doritos. Sure I'm not getting paid and this might not even make it to the film festivals but at least I'm the lead girl. I'm the girl that gets killed!!! *(She stabs herself with an air knife and falls to the ground dramatically.)* They put make-up on me. They gave me a jacket. That's almost wardrobe right? We had an actual venue. I'm just happy to have the opportunity to be on set, on film, and I even get the copy to put on my reel and the credits for my resume. I'm one step closer to becoming the (*fill in the blank of your favorite actress's name here*) I was meant to be.

(The crew begins to pack up and put everything away. Someone takes her Doritos. Someone tries to take her jacket. She fights for it. They take it anyway.) It's been months since the film wrapped and I haven't heard from the director or the producer. And every time I call them the phone goes straight to voice mail. Bastards! *(The crew peeks their heads from off stage to intimidate her to let her know that she can be heard.)* The phone was working every time they needed me to come do a pick up shot, which was four times after we were supposed to be finished. I haven't even seen the project I worked so hard on. I don't even have anything to mark my progression as an artist or show my parents since they did give me the money to make up what I didn't make at work to shoot the film. I gave up work days and weekends to make sure those little bastards got their shots for their stupid project and they didn't even have the courtesy to give me a lousy copy of the damn thing. Well I may not have gotten to see my work, but I did learn one very important lesson. Never will I EVER do another unpaid, unprofessional, non-SAG, stupid, no craft-service-having, student film project! *(She storms off stage.)*

THE THRILL OF BEING SIGNED... WHERE'S MY AGENT?
1 MALE OR FEMALE

(Actor is sitting on the couch watching TV. The audience hears various sitcom show openings as they watch the actor react to them.) I've been working really, really hard. I found good photographers, got some headshots, did a few plays, even a student film. I had spent a couple hundred dollars in postage doing mass mailings to agencies and finally, I got signed! I HAVE AN AGENT! I HAVE REPRESENTATION! I can finally go on an audition and not have to put the same number on the sheet twice for personal number and agency number. I can finally be snotty and tell someone, "Call my agent." Ha! I can finally have access to all of these projects I see on TV. I can go to the next level as actress and stop aspiring. I'm a working actress with an agent. I'm a working actress with an agent. I am a working actress with an agent. "I'm a working actress with an agent," is what I had to keep telling myself when I'd see projects on television that I was perfect for featuring people that look just like me. So I call my agent, who is supposed to be submitting me for these fabulous opportunities. He tells me, (mocking a male voice) "I don't know why you're not being called in because I'm submitting you like crazy. Give it more time. We're in a recession; there just aren't a lot of projects being produced. Or maybe you need new headshots." Funny how all those people's agents seem to be working just fine in this recession. Excuses, excuses, excuses. If it isn't one thing it's another. If it's such a recession, how come all those people are working? And headshots? More headshots? I had to take headshots to get the agent that isn't working for me now!

TIFFANY BLACK

FUCK IT, I'LL JUST BE A PHOTOGRAPHER
1 BLACK FEMALE

(Beautician enters and turns on her radio and prepares for her first customer. 90's R&B music plays as the customer, a regular, enters) So my agent says I need headshots, AGAIN. I feel like I always need new headshots. I needed headshots to get a better photographer to take my good headshots to get my agent who told me I needed new headshots to book different roles. Then I got older! Then when I sat down and thought about it, it really got ugly. As a black woman, naturally I want to change my hair at least once every month, definitely within two months. Every time you get a new hairstyle you have to change your headshots. You can't walk in with 14-inch 1B Indian Remy hair when your headshot has braids. Then I thought about the number of actors there are just in the city of Los Angeles who need headshots because somebody told them they do every day. There are thousands of us. On average we spend anywhere from $300-$700 in sitting fees alone. Then you have to pay for hair, make-up, and wardrobe for three looks to get a few hundred exposures so you can dig through and find one photo that captures the fire in your eyes and gives a performance, yada yada blah blah. Then you have to get them printed. That's an extra $50, $60! Actors spend billions of dollars every year for stupid pictures that will spend more time on the floor or crumpled in the garbage can anyway! Fuck it! I'll just be a photographer! *(She gets off the stool grabs a camera and begins to set up reflectors and lights.)*

THE LIVING HEADSHOT
1 BLACK FEMALE, 4 OTHER M/F,
2 TAP DANCERS

Photographer: As a photographer, it's my job to bring out the essence of the person so it translates into their picture. Your headshot imposes how you will be cast and how you can be used. So I want you all to take a copy of the sample text, and perform how you would like to be cast, while I take your headshots. Deal?

Actors: Deal. (They all take the copy and begin to prepare for the session. Actors wear various bright colored shirts)

Photographer: Whenever you're ready.

Commercial Actor: After a long jog on a hot summer's day, I like to cool off with a crisp, cold bottle of Tapp water. Unlike those other waters, Tapp water is full of natural minerals and ingredients that purified bottle waters get rid of. And why pay more for water that came from somebody's tap anyway. With Tapp water, you get the best of both worlds—homemade water at an affordable price. (Actor drinks water.) Get Tapp water. Tapp back into tap!

Theatrical/Soap Opera Actor: After a long jog on a hot summer's day, I like to cool off with a crisp, cold bottle of Tapp water. Unlike those other waters, Tapp water is full of natural minerals and ingredients that purified bottle waters get rid of. And why pay more for water that came from somebody's tap anyway. With Tapp water, you get the best of both worlds—homemade water at an affordable price. (Commercial actor hands her a bottle of water. She slaps him. She drinks the water.) Get Tapp water. Tapp back into tap!

Musical Actor: After a long jog on a hot summer's day, I like to cool off with a crisp, cold bottle of Tapp water. Unlike those other waters, Tapp water is full of natural minerals and ingredients that purified bottle waters get rid of. And why pay more for water that came from somebody's tap anyway. With Tapp water, you get the best of both worlds—homemade water at an affordable price. (Actor drinks water. Two additional tap dancers come in to do a quick musical number.) Get Tapp water. Tapp

back into tap!

Film Noir/Sexy Actor: (The actress fakes an orgasm and is overwhelmingly sexy.) After a long jog on a hot summer's day, I like to cool off with a crisp, cold bottle of Tapp water. Unlike those other waters, Tapp water is full of natural minerals and ingredients that purified bottle waters get rid of. And why pay more for water that came from somebody's tap anyway. With Tapp water, you get the best of both worlds—homemade water at an affordable price. (Actor drinks water.) Get Tapp water. Tapp back into tap!

I'M AN ACTOR, THEY DON'T GET IT

THE LIFE SAVER
1 MALE

I'm an actor. When I think of an actor, I think Tom Hanks, Will Smith, and John Travolta. I think of developing a body of work that is gritty, naked, real. Being someone that everyone can relate to. Being powerful. Becoming a man that every woman wants in her life and one that every man wants to model himself after. When I decided to pursue acting, I wanted to play roles that allow me to touch hearts, climb the sides of buildings, save lives! Strictly film. Then I get going and my agent sends me out on commercial audition. I told him not to waste my time. I'm better than that. I'm not selling hamburgers all day, I'm a life saver! Then he explains to me that you get paid to shoot the commercial and then you get paid every single time the damn thing airs. Do you know how much that could amount to? You know that guy who does the Verizon commercials? Never has to work again! So I do a commercial or two. Then my agent sends me out on a theatre audition. And I tell him not to waste my time, ok! I'm a life saver, ok! I save lives. I belong on a TV somewhere saving lives! He tells me to just try it; I'm perfect for the role. I tell him my Ma lives in Jersey, ok. I gotta be on TV so she can see me... saving lives! He says try it. So I try it. I go in, I get the part. And... I love it. It's the most fun I've had in years. I can't believe I got so far in life without the stage. It's a playground. It's a playground for those who specialize in playing. I wanted so badly to save lives in my work. My work saved my life.

TIFFANY BLACK

FULL HOUSE EMPTY
1 FEMALE

(In blackout, the Cosby Show theme plays and seven cast members began to perform the original choreography from the season five show opening credits. Lead actress is revealed after the dance number.) Thursday night was my favorite night of the whole week. It was for one reason only. My favorite sitcom came on Monday nights. Dad the Doctor, and Mom the Lawyer. They were the closest thing to human perfection. Sure, they had their problems like everybody else but no matter what happened everything was going to be alright within thirty minutes. At the end of the show everything would be back to normal if not better. Like magic. I wanted to live in that world. Every week my mom, dad, and my sister. We'd all watch it while eating dinner. I wanted us to be like that family. You know? Happy and perfect. I decided was I gonna be like those kids. But when my parents got divorced I thought those chances were over. They divorced when I was eight, leaving my mom a single parent. Having one parent made it virtually impossible to do anything extra-curricular. I never played sports or anything, so there was never any opportunity for me to be cheered on by my family or my mom. There was no extra money for anything like that. So I just performed any chance I got in any talent shows my school sponsored, even if it was something I didn't really want to do, like stepping. Simply because I knew the day of the show I would rather be on stage than in the audience. And every time I would be up there on stage, I'd look out into the crowd and know that my mom wasn't there. She used to say it was because she had to work or she was tired. When I moved to L.A. she couldn't come because she didn't have the money to miss work and fly here. When she got the money, she couldn't come because she was afraid of flying. She says she believes in me but how can you believe in my talent if you've never seen it? I've been acting for years and she still hasn't seen any of my performances. The house can be full and because she isn't there it's like no one is there. Sometimes I hear my cast mates complaining about the number of people in the audience. What they don't know is, my audience never affects my performance. I don't need a full house to be inspired. I give 10,000 % every

time, just in case. Just in case she had time to come. Just in case she got the day off of work. Just in case she got over her fear of flying to see me in a play. Just in case she stopped for a split second to consider how much it would mean to me if she came to support me or see how hard I work. There is nothing like having someone you love in the audience watching your work. But I'm just an actor. She doesn't get it.

BETTER MATH
1 FEMALE

(A crew enters the stage and arranges furniture and materials meticulously for the actress. They go as far as to supply a fan, and a person to hold it. The music, the instrumental to a rap song, blares as she enters. The fan blows her long spiral curled hair in the wind. She dances seductively to the music, adjusts the fan to her liking and begins to speak.)

So I'm gorgeous. I can't help that. It's not my fault. I didn't ask to be gorgeous. Everywhere I go people ask me if I'm a model, but I'm not a model. I'm an actress. My mom is getting on my effing nerves worrying about men trying to sleep with me in the industry, and if I can be frank…can I be frank? It's just us here, right? I don't mind them coming on to me. I like it actually. It's much better that way. I've done countless music videos. Easy money. Ha! Super easy money. Strippers are stupid. Duh! Just do a music video! You don't have to take anything off and you get paid the same amount of money and the entire world sees your beautiful face. They put the best make-up on you, they do your hair and you sit on a yacht in front of a fan so that you look like you're floating. It's fabulous! I make two month's rent with one shoot! Five months ago I did a shoot which led to a small part in a film and earned my SAG card. I'm an ingénue. People have so much to say about women who use their looks to get ahead. Essentially, everybody uses their looks. Some people look like truck drivers, so they get cast as truck drivers. I happen to be a stunning beauty and sometimes, you just need a stunning beauty! Should I be penalized because the directors don't wanna take the fat nanny type to lunch? This body takes work. This hair isn't free and these clothes weren't on sale. So if I have to trade a few hours of my time for dates with men who have the power and interest to get my career to where it needs to be, why not? It's better than dating a man with no money who can't do anything for my career. Hollywood looks glamorous but it's so ugly. *(Turning to face upstage and pulling money out of her back pocket to count it.)* And as long as this ass adds up, Imma keep doing the math!

THE MESSENGER
4 MALES 3 FEMALES

(A male actor stands alone on stage.) Yes I cheated on her with her best friend. Yes, I got her mother pregnant and then moved in with her father and took over his company. And after unsuccessfully attempting to commit suicide by driving my Escalade off of a cliff, I decided to go back to my wife but she left me when she found out that she and the next door neighbor was due a month after she was, both pregnant with my sons. I admit to doing all of this, but I was only playing my role of Stephen Conners on the soap opera I have been on for seven years. I'm an actor. Old ladies don't get that at all. I was at the grocery store last week and this old lady, sweet as could be, runs up to me and starts beating me with a sack of potatoes! I tried to explain to her that it wasn't real and that I would never do any of those things to any woman I truly loved. I guess I would never do that to anyone I hated. But she, along with all of the true fans of The Handsome & the Ruthless, don't get that. They all just want to blame me for ruining Rebecca - *(He corrects himself.)* Jessica's life! Part of me wants to tell them they are stupid for taking everything they see on TV to be the gospel but in reality, I'm just happy they are watching. If they are so upset with me they can barely hold a can of tuna in their hands without throwing it at me, it must mean I am giving a stellar performance. I affect them. I seem to get cast as the bad guy often. I'm always the one doing the killing, cheating, stealing, and so on. But the story can't be told if everybody plays the good guy. Everyone can't play Jesus, somebody has to be Satan.

(An actress emerges onstage.) Somebody has to be the jezebel. Someone has to be the home-wrecker. As long as art is imitating life, and husbands are really cheating with the babysitter, someone has to be the babysitter. I want to be a good example for little girls and even my peers but everybody is just not cut out for Disney. I don't want the roles I play to be a reflection of my character. I want the roles I take on to be a reflection of my talent.

(A Caucasian actress emerges.) Somebody had to play the prostitute.
(An African American actress emerges.) Somebody had to play the mammy.

(A Caucasian actor emerges.) Somebody had to play the slave master.

(An Asian actor emerges.) Somebody had to play the nail technician.

(A Middle-Eastern actor emerges until they are all standing in a straight line.) Somebody had to play the slum dog. But times have changed. Our culture has evolved, progressed. Now I can play a millionaire.

(An African American actress emerges replacing the previous.) I can play a doctor.

(A Caucasian actor emerges replacing the previous Caucasian male.) Now I can play a rapper.

(An Asian actor emerges replacing the previous.) I can play a CEO.

(An African American actor emerges replacing the Asian.) I can play the president.

(Initial lead actor.) I'm an actor. I don't always get to choose the roles I play. That is my commitment to the art. We can't judge it. It just is what it is. It's all about the story. So don't shoot the messenger. Enjoy the message. And if you don't enjoy the message, just know that we as actors show the world as is. You have the power to change it.

ACT TWO

SUPER EXCUSES
2 MALES 2 FEMALES

(Two actors, either both female or both male, walk up to the counter of a restaurant to order their careers)

CASHIER 1
Welcome to McCareer King, where you're lovin' having it your way. What can I get for you?

EXCUSES
Ah, I can't decide. Do you have any specials?

CASHIER 1
Yes, we have a couple of dating shows, game shows, and today's special is The Real World.

EXCUSES
Ah, no. I don't want any snacks I want a real career. Let's make this quick, I have a party in the hills to make it to.

CASHIER 2
I'll take the next customer. Welcome to McCareer King where you're lovin' having it your way.

SUPER
Hi, how are you?

CASHIER 2
Ah, it's good to see one of our regulars.

EXCUSES
Hey Super!

SUPER
Hey! Excuses? How are you? Good to see you here! Haven't seen you in a while!

EXCUSES
Yeah, I've been going through so much, you know, with my family going...

SUPER
Excuses. Excuses. Excuses.

EXCUSES
Yeah, well I was gonna do the...

SUPER
It's always something!

CASHIER 1
How is Broadway treating you?

SUPER
Ah, just fantastic! And that feature you suggested was just wonderful!

CASHIER 2
Well, you know what I always say, you have to stay hungry!

SUPER
And I'm always hungry. You know, it's getting to that time of year. So I'll keep it simple, I gotta be on set soon. I got my plate full through next spring! I'll just take an Emmy, a couple of Golden Globes, and an Oscar nod if you have any left.

CASHIER 2
Come on, you know we always have an Oscar nod for you!

SUPER
Oh, and we'd better super size it.

EXCUSES
Hey, that sounds good. I'll have what Super is having.

CASHIER 1
Okay...2 Golden Globes, an Emmy, and an Oscar nod. Your total is 12 years, an acting degree, 15 theatre performances, an Equity card, a SAG card, 1 divorce, 2 evictions, and a minimum of two broken limbs. How would you like to pay?

EXCUSES
I don't think I have enough. That's a huge payment! Super how are you paying?

SUPER
How about my fifteen years of experience, Bachelor's in Theatre, conservatory professional acting certificate, 150-200 auditions per year, Equity, SAG, and AFTRA memberships, 1 divorce, 1 engagement, 3 evictions, a few bodily injuries, 1 case of heat exhaustion, about a couple hundred denials a year, loss of sleep, and loss of a couple of good friends. That should cover it right?

CASHIER 2
Yes, Super. And here is your change.

EXCUSES
Ok, I get it. Fine. I can't afford that. Let me just get a feature film.

CASHIER 1
That'll be 4 years, 137 auditions, and a SAG card.

EXCUSES
Ok, well can I just have a commercial for crying out loud?!

CASHIER 1
Sure, that'll be 3 years, 119 auditions, 1 SAG voucher, and an agent.

EXCUSES
All I have is 2 years and 4 auditions. I don't have a SAG card, I don't have an agent, no evictions, no plays, no bodily harm, and I sleep very well at night thank you!!!

CASHIER 1
Ok, well would you like to have a look at our Reality Value Menu?

SUPER
Ah, Excuses! Stay away from that stuff. It's so unhealthy. You're going

to spend more time working that stuff off just to get back in shape. Thanks guys! See you soon.

(Super exits holding a bag of groceries)

CASHIER 1
What will it be? If you don't want to choose from the Reality Value Menu, the only other thing you can afford is some unpaid background work. You must not be too hungry.

EXCUSES
Background? Unpaid?

CASHIER 1
I'm sorry. It's a recession. With inflation, everything has gone up.

EXCUSES
Ok. I'll take it.

CASHIER 1
An order of background to go! Here you go. Thanks you for choosing McCareers King. I'll take the next customer.

I'M THE SHIT
1 FEMALE

(Actress stands downstage right amplifying herself before an audition. She is wearing a green shirt and has a headshot/resume in hand.)

I'm the shit. I'm the shit because I have talent, drive, and determination. I'm the shit because I can walk in any room and have everybody in the building feel my presence. People come and say hi to ME! I'm the shit because I moved out to L.A. by myself and nobody helped me and nobody believed in me and I still did it. I'm the shit because I'm beautiful. I have a pretty nose, pretty eyes, pretty lips, pretty skin, pretty face. Straight teeth and I didn't even have braces! I'm the shit because every woman wants to be it and every man wants to be with it. I'm the shit because I have bomb ass personality and I'm always the life of the party. My friends don't even want to go out if I'm not going! They fly me home just to celebrate their own birthdays! I ain't got no kids, no abortions! I'm the shit because I'm on my grind and there ain't nothing nobody can take away from me because I work my ass off! I'm the shit because even when I fall I still get back up and keep it moving. I can't stop! I will not stop! Ever! Not even when I reach my goals. I'm hungry! I'm the shit because I'm a good person and I don't have to be cut-throat about making it in this industry. I'm the shit because I'm intelligent and can't no bitch in that room touch me! I win. I can't lose. It's impossible. There is not a weapon that exists that can conquer me. I am unconquerable. I am extraordinary. I am better. There is no competition. It's nothing. Let's just face it! I'm the shit! That part is MINE because I'M THE SHIT!

(Actress calms herself down and walks over and takes a seat in the audition room.)

I'M AN ACTOR, THEY DON'T GET IT

SIZING THE COMPETITION
2 FEMALES, 1 MALE

(Actors enter the room all wearing green shirts and carrying headshots and resumes. Some are extremely happy and some are intensely serious. Some are mimicking lines in their head, some are nervous, some are calm. Some sign in on the sheets provided and some do not. The casting assistant enters.)

VO Megan: OMG. This thong is really riding me. I wonder if they'll notice if I *(she spins in circle to indiscreetly get her underwear out of her butt)*. Stop staring at me wacko!

(Another actress walks in and vaguely scans the room, signs the sign-in sheet, and takes a seat. No one speaks but we can hear everything they say. Their facial expressions reflect what they are thinking.)

VO Sizing: Eww. They have to pick me for this role. Oh my gosh. Look at her. Did she even bother brushing her hair? Hello buddy! Maybe clean your shoes for your next audition. Oh, and look at miss thing, she thinks she's the shit.

The Shit Actress: You damn straight!

VO Sizing: The nerve! And look at him. He must be here for the green film. I don't know why people go on auditions trying to remember lines. If you don't have it by now you just don't have it! They need to hurry up so I can get out of here with these peasant actors. I can't stand for people to be looking at me judging me all day long. I just need to get this commercial so I can pay my mortgage for the next few months. Happy. Happy. Think happy. Everybody in commercials are happy.

VO for OA: Why is she so happy? She must know she's going to get the part. She knows the casting director. People always say it's all about who you know. I'm from Connecticut, I don't know anybody. I'm never gonna make it. I am gonna make it. I'm gonna be the first person who ever made it from Connecticut. Connecticut is just as lame as Ohio and Halle Berry is from Ohio and she made it. Wait, Dorothy Dandridge was from there too. So Ohio must be better than Connecticut. And I'm from Connecticut. Man! Ok, I'm going to get this movie. I'm going to be in Green Killed My Mom. Green Killed My Mom.

VO Sizing: Calm the fuck down. You're making me nervous just looking

at you.

VO for OA: Well stop looking at me.

Sizing and the Shit: Well stop being nervous!

VO for OA: I wonder why they're yelling at me. Is it because I'm truly getting on their nerves or because they decided that if they both said it simultaneously it would have a bigger effect on me?

VO Sizing: Stop thinking about it.

VO The Shit: Or you could stop telling everybody what to do just because you're insecure.

The Shit: Could you keep it down? I'm trying to focus.

VO Sizing: I know this reality joke isn't actually trying to take this audition seriously.

Sizing: Oh sure. Hey, I feel like I know you from somewhere. Where have I seen you?

VO The Shit: This bitch.

Sizing: Oh, Angie! *(Instantly giving her a fake hug. And "accidentally" smearing lip gloss on her shirt)*

The Shit: My name is not Angie. Look what you did to my shirt! I'm the shit!

Sizing: *(relishing in her victory)* Not anymore you're not! You're not going in the audition looking like that are you?

VO Sizing: Silly girl.

(The Shit leaves the audition furious. Sizing is delighted.)

AUDITION CRASHING
1 FEMALE 1 MALE

Megan: Hi everyone! I'm Megan, the Casting Assistant here. If you are here for the "Get Him to the Green" commercial, please sign in on this sheet and take a look at the sides. If you are here for "Green Killed My Mom," please sign in on this sheet and take a look at these sides. We'll be starting auditions in a few minutes. Thanks for coming out.

(An actor who is signing in as Megan speaks inconspicuously decides to sign in on the other sheet too. Everybody looks at him.)

What? Like you've never done it before? The way I see it is this: I love going on auditions at places like CAZT and the Space Station. There are always other projects casting right next door. It's perfect. I'm already here. I'm already parked. I already have a headshot on me. And I'm already in audition mode. It's like a buy-one-get-one-free! Why wouldn't I crash another audition? Because it's not the right thing to do and I didn't get a call time? Who cares! Sometimes I swing by audition places in hopes of crashing an audition. I live for it. And when I submit myself online for parts, if the project notice has a date and an audition location, I'm gonna show up whether they call me in or not! It's my God given right. You have to be proactive in this business. No one is going to beg you to audition. And if I don't get the part, who cares! It's like it never happened. No harm done. No time wasted. I'm probably off to the next audition anyway! I just keep right on moving. Practice makes perfect right? I don't call it audition crashing. I call it dedication. Discipline. Diligence. Auditions lead to jobs. And if I'm not right for this one, I could be perfect for the next one. Holding an audition? Sign me up!

OVER-ANALYTICAL ACTOR
1 MALE OR FEMALE

(An actor is reading over the sides in the audition waiting room, wearing a green shirt.)

Ok so how do you think I should say this? Why did you kill my mother? Why did you kill my mother? Why did you kill my mother? No. Green no! Noooo! Green! Nooooo!! Should I fall to my knees when I say, "No green no?" Because if I fall to my knees that will seem more natural and real. No Green No! Yeah yeah! That's good. No Green No! Green you have destroyed my existence! Ok, should I say that like I'm out of breath or like I don't want to go on any longer. He did kill my mom. Maybe I'll collapse in the chair. Because if I sit in the chair the fabric in the chair will change my mood and the devastation will grow internally and erupt! No! Green! No! No Green! No! Green you have destroyed my existence! No better than that! I'll do exactly opposite of what I'm saying to create the dichotomy within my thought process. That will show the casting director that I am a man divided. That I can't even think straight because my life is destroyed because Green killed her. *(Climbing on top of a chair.)* No Green! Noooo! GREEN YOU HAVE DESTROYED MY EXISTENCE! *(Everybody is looking at him like the ridiculous fool that he is.)* There is entirely too much thought that goes into this. I wonder if the casting directors even know how much actors have thought about the stupid lines or worked on it. They don't care. They just want to get the right person for the job.

I can't believe I'm shaking right now. I'm nervous. I don't want to feel like this every time I audition or perform for the rest of my life. Casting directors probably never get nervous and it's because they are too busy making other people nervous. They are the ones to determine careers. They are the ones who get to meet all the stars. They make people stars! That sounds like way more fun than being an actor. Fuck this! I'll just be a casting director.

(The actor gathers his belongings, puts on an artsy hat and a black blazer, and takes the seat front row center.)

I'M AN ACTOR, THEY DON'T GET IT

SO MUCH LIFE…OUTSIDE THE ROOM
2 FEMALE/ 1 MALE OR FEMALE

(Actor is sitting in the audition waiting room wearing a green shirt rehearsing lines for the audition. She has so much enthusiasm. She is almost too perfect for the part.)

SANDRA
Is your son having trouble focusing after school? Does he need an extra extra-curricular activity? Well get him to the green! Down at Green Acres Community Center, we're holding little league football try-outs for ages 5-13. Bring your son down and we'll develop his talent together. If he's going nowhere, get him to the green!

(Megan enters with a clipboard.)

MEGAN
Ah, ok next for "Get Him to the Green"… is Sandra Lewis here? Sandra Lewis?

(Sandra is so engrossed in the script she doesn't notice Megan.)

SANDRA
Get him to the green! Get him to the green! Oh, me! It's me! I'm Sandra Lewis!

MEGAN
Great. You're next. Lee Skelton, you're on deck.

(Megan exits. Sandra walks to center stage, visibly nervous. Casting Director is off stage sitting front row center.)

DIRECTOR
Hi, how are you?

SANDRA
Fine. I'm fine.

DIRECTOR

Is that for me?

SANDRA
Oh yes. Yes, I'm sorry.

(Sandra hands over her headshot/resume.)

DIRECTOR
Well thank you. You're a pretty girl. Ok, just slate your name and start when you're ready.

(Sandra stands frozen.)

DIRECTOR
Whenever you're ready.

SANDRA
Yes. Yes. I'm ready. Ok. Ok. Sandra Lewis. *(She is robotic and dry. She almost sounds like it is her first time speaking English. There is no enthusiasm.)* Is your son having trouble focusing after school? Does he need an extra extra-curricular activity? Well get him to the green! Down at Green Acres Community Center, we're holding little league football try-outs for ages 5-13. Bring your son down and we'll develop his talent together. If he's going nowhere, get him to the green.

(There is a huge moment of silence.)

DIRECTOR
Thank you for coming in.

(The director exits. Megan re-enters along with the previously seen actors.)

SIZING
How'd it go girl?

SANDRA
Oh. Yeah. I totally nailed it.

MEGAN
Alright ladies! Here are some flyers! This just in, we're also casting "For the Love of Hammer," MC Hammer's new dating show. Take a flyer and apply online.

I'M AN ACTOR, THEY DON'T GET IT

(All of the girls go pick up flyers including Sandra.)

MEGAN
Oh, and you're disqualified if you've been on any other dating shows.

(All of the girls put their flyers back except Sandra.)

SANDRA
I love MC Hammer! I would fight til the depths!

TOO MUCH LIKE... ME
4 FEMALE (1 SET OF TWINS)

(A girl walks in the room extremely frustrated. She throws her tap shoes against the wall. She is wearing dance clothes.)

RACHEL
Man! Another part! She took another one of my parts. I'm so over this girl. She is at every audition I go out on. I don't get it. We went to the same school, the same dance classes, same acting school. We even have the same DNA!! I rehearse more than her! I work harder! Why do they keep picking her and not me?!

(Rebekah enters casually fierce.)

REBEKAH
Because I'm better. I am just better. It doesn't matter how hard you work, how much you try, or how hard you pray. Some people are just born...to be...BETTER.

RACHEL
(Singing.) I can out sing you.

REBEKAH
(Singing.) Then why am I the lead?

RACHEL
(Tapping without shoes.) I can out dance you!

REBEKAH
(Tapping with shoes.) Then why can't they hear you?

RACHEL
Because you're wearing tap shoes! I look better than you.

REBEKAH

That's negotiable.

RACHEL
I'm older than you!

REBEKAH
It was only by 30 seconds.

RACHEL
So!

REBEKAH
(Breaking the fourth wall.) She always makes a big deal out of that. It has nothing to do with anything.

RACHEL
I hate you!

REBEKAH
You hate me?

RACHEL
I hate you!

REBEKAH
You owe me! The only reason you have half of a career is because I book everything on behalf of this little twin gig mom and dad have going. I've been carrying this sister act since we were born. Guess you couldn't even hold down those 30 seconds while you had them. The only reason you even got into acting school was because of me.

RACHEL
You got me into acting school? I auditioned first!

REBEKAH
Lies! I auditioned in April.

RACHEL
You auditioned in May!

REBEKAH
April!

RACHEL
May!

REBEKAH
Late April.

RACHEL
Early May.

REBEKAH
Early May.

RACHEL
It was still May. I auditioned in April.

REBEKAH
Well they only let you in because they knew once they took me that I'd have the heavy burden of breaking the news to you. I should be getting 75% of the money we make because I do 75% of the work. So if I take a part from you, it is because I owned it. You're so busy trying to compete with me that you'll never get the job. I walk in the room and I am the part. I…

(Another redhead actress enters.)

NICOLE
You need to get over yourself. You know how many red head girls there are in this town who can tap? (Singing.) And sing like a bird?

(Another redhead actress enters.)

JILLIAN
Too many. You two better be happy you have each other. You got one up on us just by being born. I'll kill to have a twin.

NICOLE
Hey, we look alike…do you think we could…

(They stand next to each other and smile.)

JILLIAN & NICOLE
Nah.

JILLIAN
You two are crazy. There is no sense in ever thinking you are competing with another actress for a role.

NICOLE
Because what God has for you, is for you. And only you.

(Jillian and Nicole slap high five and exit.)

REBEKAH
You know, maybe they're right. I really don't mind being your twin.

RACHEL
You do book us a lot of jobs.

REBEKAH
But you do tap better than I do.

RACHEL
And you are a better actress.

REBEKAH
Yeah, I am.

(Rachel gives her a look.)

REBEKAH
I'm sorry, I am! But I love you. And you're going to be my sister, no matter what.

RACHEL
Sisters. No matter what.

(They grab their belongings and head for the door. They fight to open the door for the other one. Rebekah wins. They exit off stage.)

RACHEL
You just can't stand to lose, can you?

REBEKAH
Hey at least I'm fighting to be nice!

(Lights out.)

WAITING FOR THE CALLBACK
1 MALE OR FEMALE

(An actor sits on the couch with a cell phone, a laptop, and a landline phone. The actor checks various devices for messages. The actor gets up and walks around, does some push ups and squats, and returns to the devices to check volume levels. The actor prepares a glass of water and drinks it. The cell phone rings.)

Hello? Hello? Man, don't be calling me when you know I'm here waiting for a call back! I don't care if you're in the hospital! You know I've been waiting on this call since yesterday. They probably tried to call when you called and my phone made them go to voicemail. I gotta go. I need to check my voicemail. Text me. Next time you text me! *(Actor checks voicemail. No messages.)* Damn! *(Actor checks emails and goes back to pacing around the room. Actor tries to take a nap and can't sleep. The doorbell rings.)* Who is it? Tyrone! Why you knocking on my door when you know I'm waiting on a call back? Don't call me mean don't come by here either. I probably missed a phone call messing with you! *(Actor checks devices. No new messages.)* Damn! *(Phone rings again.)* Hello? Hello! Yes. Really? I'd love to. Thank you so much. The commercial? That's right, the car commercial! So I'm the one talking about the car. I'm washing the car? No, no, no! That's fine. Background work is fine. *(Under his breath.)* Long as I'm in something. So the address is…?

LOVE FIRST.
2 MALES

(A romantic ballad plays. A male dancer takes the stage and begins to dance. Lead actor timidly walks to center stage, almost child-like, growing more mature as the piece progresses. One male dancer dances interpretively in the background very subtly.)

Ever since I was a little boy I have been in love with movies. Whenever my birthday would roll around everybody knew I wanted one of two things as a gift, to go to the movies or to own one on VHS, which later became DVDs. Today I own at least five hundred titles or more and that's after I replaced them when someone broke into my apartment and stole ONLY my movies. For as long as I could remember, all I have ever wanted to be was an actor. My friends call me a walking IMDBPro. I love acting so much, I tend to love people who love it as much as I do. All of my closest friends are in the industry in some form or another. I just fall in love with them. I fell in love with him. He was an artist, an amazing artist. He could dance so powerfully it made you feel something by just watching him. The first time I heard him sing, it took my breath away. It gave me goose bumps, kind of like the way Jennifer Hudson's voice did when I heard her sing that one song in that one movie. His approach to art inspired me. It made me fall more in love with art. I fell more in love with him. We did everything together. We painted. We went to the movies. It was the happiest I'd been since Scream 1, 2, & 3 came out in a collector's edition. Once we went out and he tried to hold my hand. It caught me off guard. I wasn't ready to share my love with the world. Sure I was fulfilled. I was better than happy. I was joyous. The only problem with that is that this industry doesn't want to hear about homosexuality. They don't want to cast an open gay man in a straight, womanizing role. I don't want to end my career before it even gets started. The thought of someone seeing me, with him, like that, made me sick to my stomach. He knew exactly how I felt. Offended by my shame, he left me. *(The music fades out. The dancer exits. The actor continues to speak in silence.)* Suddenly, it became hard to breathe. The smell of food nauseated me. My body was too heavy to stand on my feet. I

was torn. How could the very muse that made want to become a better artist, be the same thing to keep me from reaching my full potential? And I'm not about to settle for playing a bunch of flamboyant sidekick roles. I'm not wearing any wigs and dresses just because of who I am. I am a man. A man who just happens to be in love with a man. *(The music resumes and the dancer dances. The actor watches lovingly.)* It took a lot of work, begging and pleading to get him back in my life. It took even more to earn his trust, to make him feel safe with me. I've felt what it's like to live without him and I never want to feel that way again. It's not fair. Other people don't have to choose between their first love and the love of their life. And neither will I. I'm an actor, not a sexuality. They don't get it.

I'M SCARED
1 MALE OR FEMALE

The truth is that I'm scared. I just don't know if I have what it takes to make it. Nobody I ever knew with a dream like this ever made it. So why should I ever make it? I know I need to be doing more for my career but I don't even know where to start. There is no blueprint, no plan, no path. Everybody who ever made it in acting has their own story. I don't know. I want this more than anything in the world, but I can't help but doubt my talent sometimes. What if my talent isn't enough? Hell! Some people make it with no talent at all. There is no rhyme or reason. Sometimes it's just who you know. I don't know anybody! I'm not from here. Who am I to actually make it? Yesterday I felt like I knew so much and today I feel like I don't know anything! What if I fail? What if I fall flat on my face? I could try for years and years and never make it. That terrifies me. But you won't know if you don't try. I feel like I have no control over my destiny. It's all contingent on other people's decisions. Actors are the last people to be added to a project. We don't produce them, or write them. We just wait on other people to create opportunities for us. I don't want to be afraid, but I can't help it. The things against me seriously out-number the things in my favor. And after about 6 months of not booking anything, nobody believes in you anymore. People don't believe in you until you're actually doing something. Without my hope and the will to make it, I have nothing. These thoughts go through my mind every day. If I don't work overtime, they will eat me alive. I know I don't have the desire to do this by chance. It's so strong. I don't know how God decides who will get what they want out of life, but I hope like hell I'm on the list.

FAMILY SUPPORT
1 FEMALE

Hello? Hey Ma. How you doing? Yeah? That's good. Oh, me. I'm alright. Yeah. Yeah. I'm working on it. How is granny doing? Yeah, I have an agent. And Uncle Fred? I'm working on it. These things don't just happen overnight. I'm in a play right now. Right now as we speak! No it isn't paid. Because I need the experience Ma! You are going to see me on TV. Hey, that's not fair. There was a robbery in my apartment complex and I was standing right behind the reporter when the news team came. I did that one commercial. Well they needed people to fill the arena when they were filming the concert scene. It was a Mariah Carey concert! That was huge. I have worked with Mariah Carey! How many people can say that? That you know! Yeah. Yeah. Lots of stuff Ma. Hey I met Steven Spielberg last night. Steven Spielberg Steven Spielberg. Thee Steven Spielberg. He directed The Color Purple. Yeah, well I didn't actually meet him. He came into the restaurant I work at for dinner last night. Yeah, yeah. Well he said I had a lot of potential. Yeah Ma. *(Looking out of the window.)* I see the Hollywood sign every day. I remember that! That was my favorite time of year just because I knew I was going to get to be in a Christmas play. That's right! I'll always be the original baby Jesus. Always. I am focused. I never forget. Thanks Ma. Hey Ma? Nothing, nevermind. I love you too.

I'M AN ACTOR, THEY DON'T GET IT

PACKING LIGHT
3 FEMALES/ 2 MALES

Three years. I gave him three years. I'm supposed to have my ring, my dress, and my house by now. But no. After three years, I'm walking away with nothing. My heart isn't even broken. It was one of the easiest decisions I have ever made in my life. We dated for two years in college, *(A male actor walks up behind her and kisses her on the cheek, hugs her from behind and then leaves to exit upstage. Another actress walks by. He begins to follow her offstage.)* then he graduated the semester before I did and moved back home to "save money to pay back his student loans." I took it as him being responsible. He's thinking about our future. He's saving money for our house! He's saving money for my ring! What woman could be mad at her man for that? So I graduate and it's time to decide what to do with my life. And even though he knows that my heart is in acting and I've wanted to move to Los Angeles since I could remember, I offer to move to his hometown to be with him. He objects. He not only objects, he completely shuts the idea down before I can fully sell him the dream. I'm no fool. I accepted it for what it was. Even though we had been together for two years by that time, he's nowhere near ready to settle down with me. And I'm not one to go chasing a man so I did what any twenty-two year old girl would do, I moved to L.A! I decided only good things could come from this. One - he misses me so much he can't breathe, he buys me a ring and we live happily ever after. Two - I pursue my acting career with no local distractions and become an incredible actress and live happily ever after. Or three, he can't hold up in the long distance relationship and ends up not being the one for me and I meet a mogul who falls madly in love with me and we live happily ever after. Eventually, the three-hour time difference strangled us. He couldn't understand that I had to work all day, I had class at night, and then I had to rehearse with my scene partners with whatever time was left. *(Boyfriend sneaks outside the door upstage with only a sheet covering the lower part of his body and mouthing on a cell phone. The audience sees only a female hand reach out and pull him back through the door.)* I called him every break I had, every chance I got. I'd get up extra early to talk to him at 4am my time before he went to work. When it came down to it, he just couldn't relate to me and what I was trying to accomplish. He couldn't support my dreams because he didn't have any of his own. Looking back on it, he never once told me I was going to make it. He didn't believe it. He didn't believe in me. Talking to him started to feel like putting on a pair of jeans that were two sizes too small. I could

wear them if I wanted but they were terribly uncomfortable and bad for my self-esteem because I had completely outgrown them. He was squeezing the life out of me. *(An actress begins to sing a break up song off stage.)* Well, everything happens for a reason. I'm going to put all of my energy exactly where it needs to go, into my career. But hey, two out of three ain't bad. I'm an incredible actress and *(A gorgeous, tall male actor, wearing a business suit, crosses in front of her.)* I think I just met that mogul. *(The actress is greeted by the mogul. They chat with words the audience cannot hear. The ex-boyfriend enters to see them exit the stage together. The singers enter the stage and begin to sing a song to the remorseful ex-boyfriend. The singers walk out on him.)*

I'M AN ACTOR, THEY DON'T GET IT

GIVING IN TO GIVING UP
3 FEMALES 1 MALE

(An actress is sitting at a table eating like she has never eaten before. A male actor walks in.)

Taye: What are you doing? Did somebody send you some money or something?

Khandee: Why you say that?

Taye: Because you scarfing that food down like it's your last supper and you're spending at least ten dollars on that meal after tax and a tip.

Khandee: I don't care. I'm tired of being hungry. I eat McChicken's and a small fry every day because its only $2.17 because I don't have any money to be wasting on food. I'm homeless. Sleeping at my job. Do you have any idea what it's like to jump a fence to sneak into someone's room? I could get kicked off campus permanently if they find out I've been staying there. I haven't gotten a good night's rest since I've been back in LA. I've been on seventeen auditions in two weeks. And nothing! I ain't booked nothing! I'm not giving up. I'm just going to go home and re-group for a while. I'm tired of this. I'm hungry.

Taye: So you're giving up.

Khandee: No I'm not! You don't get it. I have to keep my toothbrush, deodorant, and my phone charger in my purse every day because I don't know where I'm going to sleep at night. You have a place to live. You have food to eat.

Taye: I eat the same McChicken's and small fries you do and I throw you over that fence! You're disgusting.

Khandee: Shut up!

(Khandee gets up to go pay her check. There are two women talking in line ahead of her. Impatient, she puts her cash on the counter and heads for the door.)

Taye: Khandee! Do you see who that is?

(Khandee turns around. One of her favorite actresses, Angelica Washington, is standing there looking at her. Khandee is devastated and runs outside.)

Taye: Khandee! Khandee! Angelica can you please talk to my friend, Khandee? She is a huge fan of yours and she's just upset right now.

Angelica: Khandee? What's wrong?

Taye: She's an actress. She just graduated from acting school last month, she got her bachelor's last year, but she's homeless now, and she's giving up because it's getting hard, but she really shouldn't because she's really talented.

Angelica: Is that true Khandee? Stop crying. You're so beautiful. You sound like you work really hard. Sounds like you've put a lot into your career already, you can't give up now. How old are you?

Taye: 23, but she'll be 24 in March.

Angelica: You're still a baby. I've been in this industry as long as you've been alive. I've been there. From bathing in the ocean, to sleeping in my car. But I knew God was going to bring me through. You have to trust Him. You believe in God?

Taye: Yeah she does.

Angelica: You gotta trust in Him then. I had an agent who told me my career was over, but I didn't let that stop me. I hadn't worked in years, but I kept right on going. I never gave up. You can't ever get off your mark. If you quit, you're going to be giving your spot to the next chick who stayed in the game. And I don't know about you but I'm not giving my spot to nobody else! Now come on, I'm gonna pray for you. Lord, we just want to say thank you right now. Thank you for waking us up this morning and giving us another day to do your work. Lord, I want you to watch over Khandee. I want you to send her a good job so she can get on her feet and have the strength to make it through this tough time. Let her know that you are God and God alone. We give you all the glory. In Jesus' name we pray. Amen.

Taye: Amen.

Khandee: Amen.

Angelica: Things are gonna get better Khandee. What are y'all about to do now?

Taye: Nothing.

Angelica: Well my acting class starts at 7. I want y'all to come. And Khandee I want you to come every week. It's every Wednesday at 7. You can come for free for 3 months until you get on your feet. And you can come too.

Taye: Me?! Oh thank you so much Angelica! I'm Taye.

Angelica: It was very nice to meet you Taye. You too Khandee. Ok, I'll see yall in a few. Girl stop crying. It's gon get better.

Taye: Bye, thank you.

Khandee: Thank you so much.

(Angelica exits. Khandee and Taye both cry and laugh.)

THE DECLARATION 2
4 MALES OR 4 FEMALES

(Actor sits down for an interview about upcoming film.)

Host: Welcome back. So tell us, how does it feel to have a blockbuster hit on your hands?

Actor: Like God's favor. I feel phenomenal. I've dreamed about this for years.

Host: And how did you end up working on this summer's hottest horror flick, "Green Killed My Mom?"

Actor: I was actually at the audition for Green and I met the Casting Director, Max. Hi Max!

Max: *(From his seat in the first row.)* Hey buddy!

Actor: I auditioned, confirmed it at McCareer King, and the rest is hard work and history.

Host: Boy aren't we glad you never gave up on your dream! What does being an actor mean to you?

Actor: I'm an actor. This is not just a hobby, an elective, or a job. For a long time it couldn't even be considered a job, because I wasn't even making any money. I am an actor because it's the only thing I love to do. I can't help it. I do it without even trying. I study people, the way they walk, talk, live life. It fascinates me. This is my passion, my childhood dream, my only dream. I gave up everything to come here and do this. I know there are thousands of people who move L.A. every day to do what I want to, but I don't care. I know there are thousands that pack their bags and give up every day, and I don't care. I'm different. I'm making it. I had to. If I don't act, I die. If I don't make it I have nothing. I refused to go home empty-handed. I promised my mom a new house. I bought that house for her last week! I've always wanted to do that for her! So I had to make it. I've been waiting on this my entire life. I saw it. I still see it. I'm not like all these

other fools who get off the plane and hope to get discovered in a coffee shop. I would not have cared if I never became famous. The money is great but most importantly, I just want to act. I want to continue to tell beautifully amazing, life-changing stories. Miracles happen to human beings every day. We don't share in those stories enough. When we watch movies, TV shows, plays, films, we look into people's lives. We learn. Our minds expand, we make fewer mistakes. We have compassion for others. We actors are able to touch other people and enhance lives. I knew it was not going to be easy, and I looked forward to the hard work. This is what I love to do. I won't stop now that I've made it. I worked too hard to get here. Who cares if people look at me crazy. I'm an actor. I'm an actor, they don't get it.

Host: That's it ladies and gentlemen. Here's a prime example, when you're giving your all to something you love, you make it. When you truly follow your dreams…you make it. Thank you for taking time with us.

Actor: Thank you for having me. It feels good to make it.

(Actor waves to the audience, puts on sunglasses and prepares to leave. Paparazzi photographers start taking pictures of the actor.)

Felicia: *(As one of the paparazzi.)* It feels good to make it.

Max: *(Shaking lead actor's hand.)* It feels good to make it.

Sandra: *(Dressed scantily clad wearing a large clock around her neck.)* It feels good to make it.

Fade to Black.

TIFFANY BLACK

I'M AN ACTOR, THEY DON'T GET IT

ABOUT THE AUTHOR

Tiffany Black is a native of the lovely shores of St. Petersburg, Florida. Her training is extensive with both a bachelor's degree in Communication with an emphasis on African American Studies from the Florida State University and professional Studio Acting certificate from the American Musical and Dramatic Academy, Los Angeles. She has also studied the Ivana Chubbuck Technique with one of her favorite actresses, Tasha Smith, while also studying comedy at the Upright Citizens Brigade. Her dream role is Winter Santiaga of one of her favorite novels, The Coldest Winter Ever by Sistah Souljah.

Tiffany founded her production company, Tiffany Classics, LLC specializing in producing only classic material. Since 2009, she has written, produced, and starred in projects featuring concurrently in the NAACP Theatre Festival as well as the Hollywood Black Film Festival. In 2011, Tiffany Classics launched www.PlentyPennies.com, a network exclusive to quality black webseries content. In 2014, Tiffany published her first book, *The LA Actor Conquers the Atlanta Market*. Tiffany continues to write and produce entertainment content.

Tiffany relocated from Los Angeles to Atlanta in 2013 but maintains residency on both coasts. For more information, please visit www.TiffanySBlack.com.

www.ingramcontent.com/pod-product-compliance
Lightning Source LLC
Chambersburg PA
CBHW051819170526
45167CB00005B/2079